IN THE PRESENCE OF
ELEPHANTS

IN THE PRESENCE OF
ELEPHANTS

TEXT BY
PETER BEAGLE & PAT DERBY

PHOTOGRAPHS BY
GENARO MOLINA

CAPRA PRESS
SANTA BARBARA

Cover and book design by Frank Goad, Santa Barbara.

LIBRARY OF CONGRESS CATALOGING-IN-PUBLICATION DATA

Beagle, Peter S.
In the presence of elephants / text by Peter Beagle & Pat Derby :
photographs by Genaro Molina.
p. cm.
ISBN 0-88496-396-9
1. African elephant—California. 2. Captive wild animals—California.
3. Wildlife rescue—California.
I. Derby, Pat. II. Molina, Genaro. III. Title
QL737.P98B33 1995
639.9'7961—dc20
95-24507
CIP

CAPRA PRESS
P.O. Box 2068, Santa Barbara, CA 93120

In memory of Rose Arenal
"Tia"
——PETER BEAGLE

For Amanda Blake, Kim Basinger, Alec Baldwin, Tony LaRussa
——PAT DERBY

For Patty Housen
——GENARO MOLINA

Grateful acknowledgements to Michael Allen Jones for his friendship, support and constant advice which he so generously offers; to Irene Fertik, for the use of her darkroom, who helped make printing the photographs for this book such a pleasure; The Sacramento Bee; and to Pat Derby and Ed Stewart whose commitment to her family at PAWS exceeds parenthood.

IN THE PRESENCE OF ELEPHANTS

PETER BEAGLE

author of *The Last Unicorn* and *The Innkeeper's Song*

THEY SHOULD NOT BE HERE. Their home is Africa, Asia; their home is in our visions of power and majesty and wisdom; they no more belong in a zoo's enclosures or a circus's degradation than whales belong in marine theme parks, no matter how much their jailers may love and respect them. Nevertheless, they are here.

Human beings have been domesticating and exploiting elephants for at least 5,500 years, far earlier than Hannibal's use of them as war towers and pack animals in his challenge to the Roman Empire. In India, Sri Lanka, Malaysia, Indonesia and parts of South China, they still serve as logging trucks, tractors and bulldozers in roadless areas where machines cannot go. In the industrialized countries they were on exhibition well before Barnum's Jumbo; they have been brutally taught to dance, to roller-skate, to do headstands, to perform in movies and theaters, and above all to fear men with guns, clubs and electric cattle-prods. And when they grow too old to work, or when suffering has filled them too full of rage to pay any heed to the cattle-prods, then they are killed or simply abandoned to the mercies of anyone who thinks he might like to have an elephant, and has a big enough packing crate out back, and maybe a friend on the local zoning commission. Whatever their situation, they spend their lives in chains.

While much overdue concern is currently focused on the horrors of the ivory trade, poaching, loss of habitat and the myriad of other problems that elephants face in the wild, little attention

is paid to the captive elephant. In recent years the best books and films ever devoted to wild elephants have appeared from a wide range of writers and naturalists all over the world; but the last definitive book on "domesticated" elephants was published in 1911. This is particularly ironic in light of the cold fact that some form of captivity is obviously the future for all elephants. One possibility may be Dr. Richard Leakey's proposal to fence off protected habitat in order to prevent herds from doing damage in populated agricultural areas. Safe from destruction without being condemned to solitary confinement on chains or behind bars. They would also, in essence, be prisoners in their own jungles. Yet this may be the very best that a few last handfuls of wild elephants can hope for in the coming century.

Pat Derby and Ed Stewart make up half of the only elephant herd in Galt, California. It's a long story. Pat Derby is an English-born, Cambridge-educated, bass-thumping former actress and club singer. mother of the Enco tiger and the Lincoln-Mercury cougar, a descendant of Mary Shelley, and the nearest thing I ever met to Dr. Doolittle. She may not speak all animal languages (though she once gave me a crash course in Basic Tiger), but she can *think* like an animal, which amounts to the same thing. Ed Stewart has been Pat's sidekick, bodyguard, architect, construction foreman, road manager, resident therapist, and general all-around henchman for the past eighteen years. People who don't know better tend to regard him as the sane one.

In 1984, Pat and Ed, having become involved in the exposure of massive brutality to animals employed in films and nightclubs, formed the non-profit Performing Animal Welfare Society (PAWS). In addition to working to protect animals in entertainment, PAWS was established specifically to provide a sanctuary for abused and abandoned captive wildlife. This book is about two of them.

Mara is a young female elephant whose mother was killed in Kruger National Park as part of a cull—the slaughter of elephants to control population. Purchased by an animal dealer, Mara was brought to the United States and became the main attraction at the San Jose Zoo in California. When she outgrew her display, the zoo director sold her to a Mexican circus, and was preparing to replace her with a younger orphan when 200 furious

picketers stormed his office, demanding that he cancel the sale. The story made national headlines. The director capitulated as briskly as he'd first made the deal.

The protesters, associated as the "Friends of Mara," contacted PAWS, asking for help in purchasing the elephant and finding a good home for her. Having at the time neither the money nor the facilities to house Mara themselves, Pat and Ed sought out a Florida compound called Jumbolair, owned by Arthur Jones. An eccentric millionaire straight out of a 1930s screwball comedy, Jones had airlifted 63 baby elephants from Zimbabwe to his ranch in Ocala, Florida. On the assurance that she would not be chained, trained or in any way manipulated by her handlers, Pat and Ed brought Mara to Jumbolair.

They stayed a week to accustom her to her new surroundings; which, as Pat says, "was our undoing." Strolling the compound observing the other elephants, they met "71," the youngest and tiniest elephant at Jumbolair. (Cue to the size of the herd, and for the sake of expediency in providing veterinary care, all elephants at the facility were given numbers as names.) Although the rest of the herd was thriving, "71" suffered from an endless variety of medical problems. In the wild, baby elephants are constantly protected by their mothers and at least one other female—an "aunt"—who monitor play among the infants and prevent bullying by stronger playmates. As a helpless orphan "71" had no chance in the competition for food; but isolated from other elephants, she grew depressed and apathetic, and hardly ate at all. Her teeth were soft from lack of her mother's milk, and she had agonizing bouts of colic almost weekly. And yet she clung to life as stubbornly as though it had been kind to her.

Not long after Pat and Ed's visit, "71" was taken to the veterinary hospital at the University of Florida. Surgery was performed on her teeth; attempts were made to control her near-constant diarrhea and colic. But when Pat and Ed saw her next, some months later, she looked like any malnourished child, with her ribs showing and her grotesquely bloated stomach almost touching the ground. Everything medical that could be done for her had been done. Her death was considered a matter of days.

Arthur Jones surprisingly agreed to the sugges-

tion that "71" be brought to California for last-ditch nursing, with the understanding that she would be returned to Jumbolair if she somehow pulled through. Pat and Ed could barely manage their own travel expenses, let alone those of an elephant; but after thirty years of scuffling to feed her brood, it is entirely possible that Pat knows every animal soft-touch on at least three continents. The actress Lindsay Wagner and her fan club eventually raised the money for "71"'s transportation, and in August of 1986, to a barrage of media coverage, Galt's first elephant—who had not been expected to survive the journey—arrived at her new home.

Social life among wild elephants centers around the youngest, and the entire herd will stop moving to assist an infant in distress. From the day she arrived, "71" began assembling her own herd, with Ed and Pat as mother and aunt, one or both always in attendance even while she slept, watching her breathe as she lay on her side, her trunk curled up in a little ball. Slowly her appetite began to improve on a diet custom-tailored to her fragile digestive tract. Her stomach was still unnaturally distended, and Pat and Ed still held their breaths every time they opened the barn door in the morning; but she was plainly stronger and steadily gaining weight. Her fierce will to live was finally growing an elephant around itself.

As elephant calves develop they begin to interact more within the herd. They are extremely tactile animals, and touching, especially with the trunk, is a vital part of social relationships. Pushing and shoving develops later, as positions in the pecking-order establish themselves among siblings. "71" taught Ed the basic baby-elephant game, which involved their spending hours—Ed on his knees—shoving against each other, to her loudly intense delight. Baby elephants squeal like children, purr much like cats, rumble like backhoes, and urinate copiously when they're really having a good time. It's a bit disconcerting at first.

Elephants usually take to water almost on sight, but "71" detested it at first, only tolerated it warmed for bathing and drinking, and then discovered the magic of mud. An elephant's skin is a lot tenderer than it looks, and wild calves learn what mud is for at an early age. "71" worked up a proper wallow with her bathwater, figured out the trick of flinging the soothing goo all over herself with her trunk, and settled down to make sure she

never allowed herself to be clean again. The lavish trunk caresses for friends and strangers alike continued, but they were now referred to as "slime-ing."

Growing steadily more playful, she began to invent games involving riotous mock-charges at the birds—and the one unruffled housecat—who dared to invade her corral; and she developed a grand passion for a truck tire, which she carried about with her, carefully leaning it against the rail when she stopped to eat or drink. When Pat and Ed were with her, she invariably stood the tire next to them, as though lining all her prized possessions up in a row. She gained 300 pounds in a relatively short period of time; by mid-1988 she had grown as tall as Pat and weighed over 1500 pounds. This made her notably more gentle when she played the pushing game with Ed, but it in no way altered her habit of leaning sleepily against her human companions, one back foot daintily crossed over the other. And she discovered the glorious secret that all elephants share—the tongue rub. Wild elephants greet each over by placing their trunks in one another's mouths. "71," ever inventive, adapted this greeting by placing Pat and Ed's heads in her mouth, and added a crowning touch when she learned to steal Ed's cap as he blew on her tongue.

Ironically, by the terms of PAWS's agreement with Arthur Jones, the stronger and healthier "71" grew, the closer came the inevitable time of her return to Jumbolair. However, the news in late 1988 that the Florida compound had been sold brought more distress than rejoicing to twenty acres of Galt. Jones's pet herd of elephants, whose future had seemed so secure, was to be sent to an animal trainer who would break them to chains and train them for performances. Mara, PAWS's refugee from the San Jose Zoo, was back where she had been two years before, and with no outraged picketers to rescue her this time.

PAWS had been established with just such situations in mind, and Pat and Ed would undoubtedly have taken in the entire herd if they could. But at the moment they were barely able to deal with "71"'s immediate need for new quarters—she now weighed 3,000 pounds, and had outgrown her interim corral and barn—let alone an elephant of equal size who had just lost her bonded herd and was leaving a better situation than PAWS could provide for her. Even so, if even one ele-

phant could be kept from training, it had to be Mara; and "71," for her part, needed more than human companionship. The time had arrived, very abruptly, to expand the Galt wild herd.

Preparations for bringing Mara to a suitable elephant habitat quickly got underway. Two local construction companies helped to dig a lake, and Ed and Pat planted fruit trees, bamboo and other edible vegetation in the surrounding area. Ed—the Frank Lloyd Wright of pipe construction—built a second corral adjoining "71"'s, so that she and Mara could grow acquainted without running any risk of fighting. He also enlisted a local cattle trucker to drive him to Florida to pick up Mara. It's four days each way, and distinctly longer with an elephant.

Mara was, among other things, decidedly not "71." She had made friends with Ed on the journey from Florida, but she had a lot of reasons to be upset with her situation, and she took them all out on Pat immediately upon her arrival at PAWS. Two weeks of terrifying charges across her brand-new corral, ears flared, bellowing trunk swinging like a Viking war-hammer, reduced Pat to her own reluctant weapon of last resort: out-and-out bribery. It broke one of her oldest rules—it's never a good idea to have a very large animal come to regard you as a walking snack bar—but Ed was already being allowed the familiarity of scratching Mara's tongue, while Pat couldn't get near her. Desperate times require desperate measures.

For several days Pat did very little but roll apples, carrots and bananas to Mara, until the elephant began slowly to reconsider the relationship. Accepting food was one thing, however: the day that Mara tentatively stretched her trunk out, not to pick up an apple, but to touch Pat's face remains one of the great moments of her life. She says of it simply, "There is nothing more gratifying than the acceptance of an elephant."

After that, Mara capitulated totally, shamelessly surrendering herself to the pleasures of tongue-rubbing, scratches behind the ears and appalling babytalk yelled up her trunk. On her own she reinvented "71"'s game of greeting Pat and Ed by taking their heads in her mouth; the only difference being her delight in having loud, raucous raspberries blown on her tongue. You probably have to be an elephant to understand this one, but it matters to Mara.

When the decision was first made to bring Mara to live with "71," Pat and Ed had expected a variety of reactions from both elephants, ranging from aggression to jealousy to plain pleasure. What they never anticipated was total indifference. "71" seemed quickly to lose interest in the new arrival, while Mara regarded her with obvious disdain, as though comparing her unfavorably to her companions at Jumbolair. Except for their both being females, it was like the first day of dancing school.

Formal introductions were obviously called for. Pat and Ed instituted daily orientation sessions, walking "71" up to Mara's corral in hopes that the two would begin the elaborate getting-acquainted ceremony practiced by their wild relatives. It was reasonable to assume that Mara, raised in a herd, would know the rules of the ritual; but "71" was another matter. Elephants are profoundly social animals, dependent on the group not only for their lives but for their individual centers of gravity: in that case, can an elephant truly exist in the deepest sense without other elephants? The bonding with humans which had saved "71"'s life might equally have robbed her of her deepest nature. "Jurassic Park" to the contrary, DNA isn't everything.

But it can come through in a crisis. Slowly Mara and "71" began to demonstrate all the trunk-touching, rumbling, spinning, backing, urination, defecation and ear-flapping that is normal behavior for elephants meeting in the wild. The trunk-in-the-mouth greeting, which both elephants had individually modified to accommodate Pat and Ed, was initiated by Mara; which accurately suggested, according to wild-elephant chronicler Cynthia Moss's findings, that "71" would prove to be the dominant one of the pair. In any case, the Galt herd has definitely established itself.

Mara herself is a serious person, in comparison with the bouncy, buoyant "71." Her greatest joy is in water: she will stand in the heaviest downpour, splashing and breaching like a whale, demanding that Pat and Ed stay out in the rain and play the hose on her. It is strange and fascinating to hear her delighted vocalizations, which are remarkably similar to the clicking chatter of whales and dolphins. Pat has heard this Morse Code of heightened pleasure once before, from an elephant born in South Africa, as Mara was. The evidence for it as a particular local dialect is inconclusive; what is certain is that "71"—who stays sensibly indoors

on Ed's heated barn floors during storms, and still avoids baths unless both water and weather are warm—has recently begun making the sounds herself. Pat attributes this to night classes in the barn.

Today "71" and Mara play together in the lake and course around the edge of their domain, chasing egrets and herons, grazing, dusting, mudbathing and barking the huge trees donated to PAWS by Greg Luckenbill, a Sacramento developer. They spent a lot of time with the trees, pushing against them to test their strength, and digging in the root balls for succulent morsels. The new fruit trees, grape vines and bamboo are growing rapidly, and will eventually provide browse and food variety suited to the voracious appetites of mature elephants. The herd will survive.

More, it will grow. At this writing (July 1995), two African elephants named Tamara and Annie are scheduled to arrive from the Milwaukee Zoo in a matter of weeks. Unlike Mara and "71," these two aren't kids: they were captured wild as babies, and they have lived in captivity for some forty years. At least three-quarters of that time they were on chains. Tamara has a bad foot, Annie an arthritic hip. Neither has ever experienced any-

thing like the gentleness, respect and concern that the Galt elephant herd has come to take for granted; neither has ever in her life made a single choice that was not dictated by avoiding pain. Ed, working almost single-handed through a searing Central Valley summer, has built a heated shelter for them, and they will have outdoor space, trees and water and comforts of their own, regardless of how well they interact with Mara and "71." And even so, it may be too late for them, as it would be for human beings who had lived as they have lived. I knew a hawk once who had been kept in a garage for so long that he was terrified of the sky.

In the end, no one is more aware than Pat Derby, Ed Stewart and the staff of devoted volunteers who keep PAWS going of the essential wrongness of even the best-loved, best-cared-for elephants being in Galt, California at all. There is no way to compensate anyone for the loss of their bone-proper place in the world. "71" and Mara may have as natural a life as is possible for captive elephants; but it *is* captivity, and it cannot ever replace the wildness they were born to inherit. "They know," Pat Derby says. "I'm sure they know."

1.

"71"

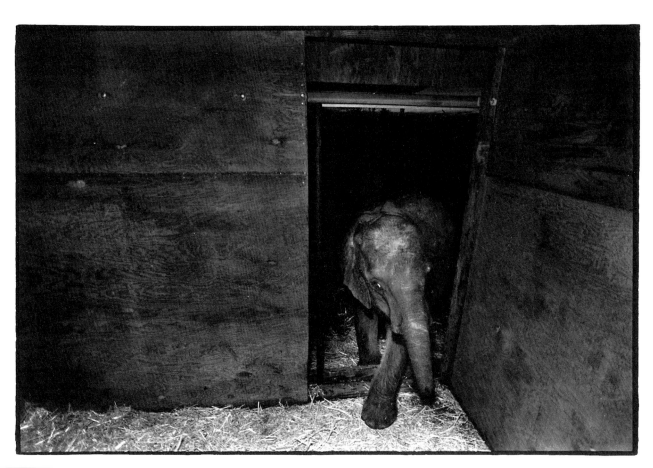

"71," shortly after her arrival. She was a sickly four-year-old, the size of a newborn calf.

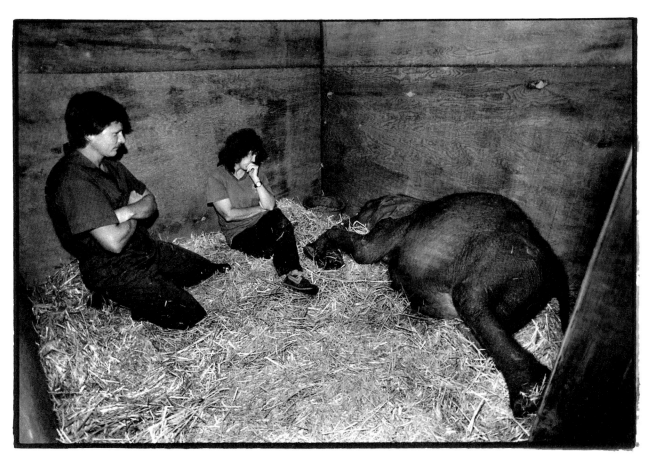

Pat and Ed keeping late night vigil.

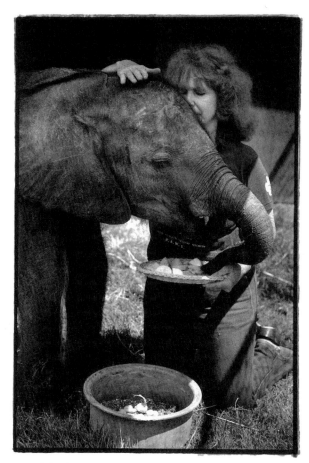

Hand-feeding "71."

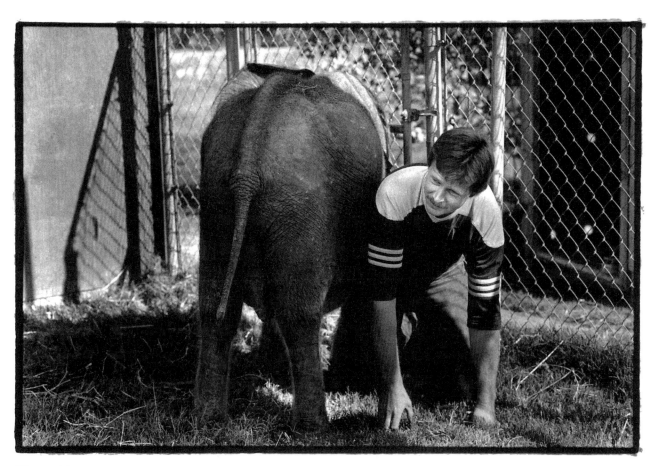

The pushing game.

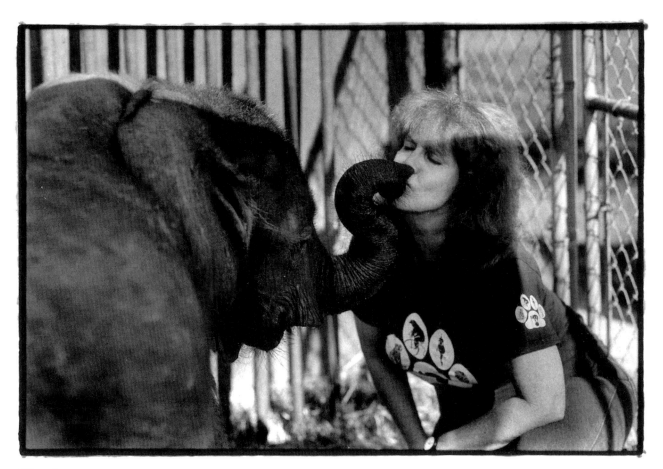

Slime-ing.

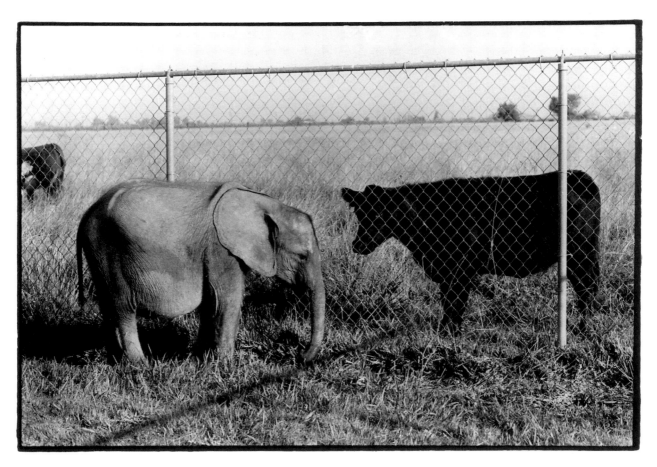

A curious neighbor.

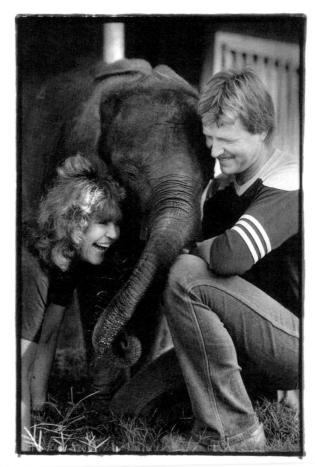

Family portrait.

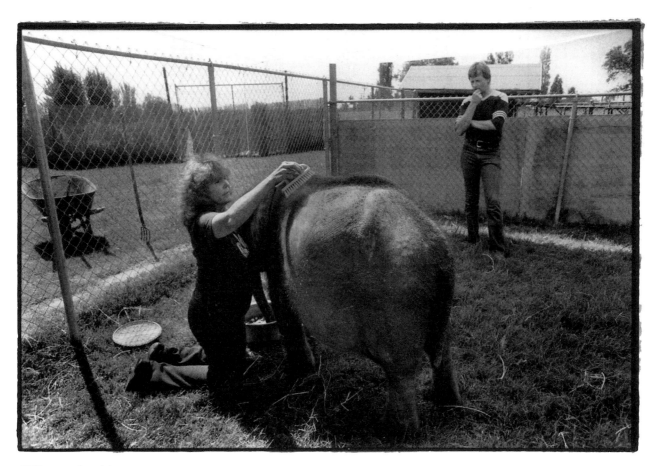

"71" gets a brushing.

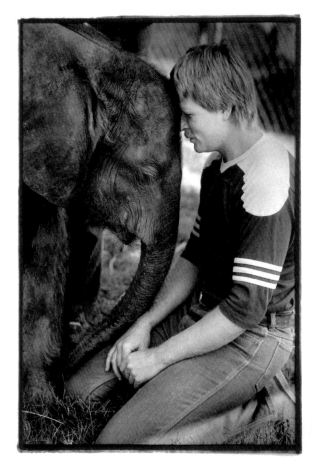

Head to head.

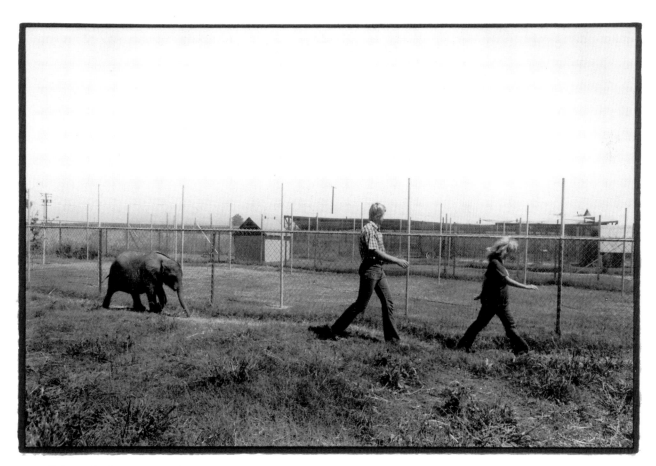

A stroll through the compound.

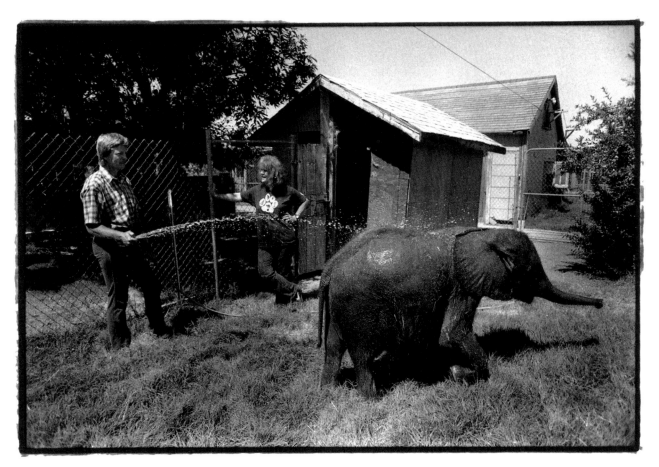

First, a rinse…

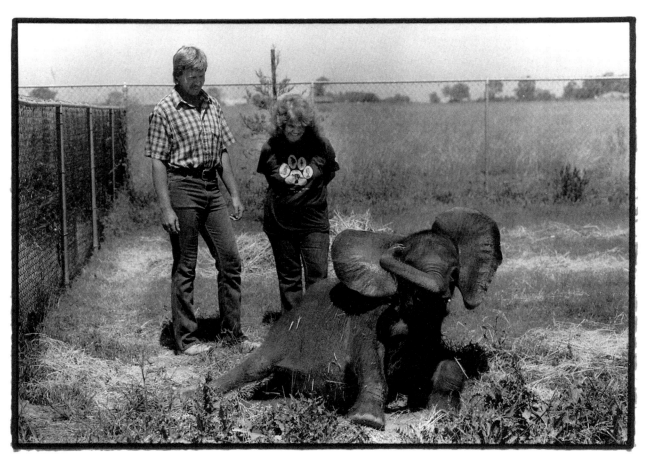

then a mud bath.

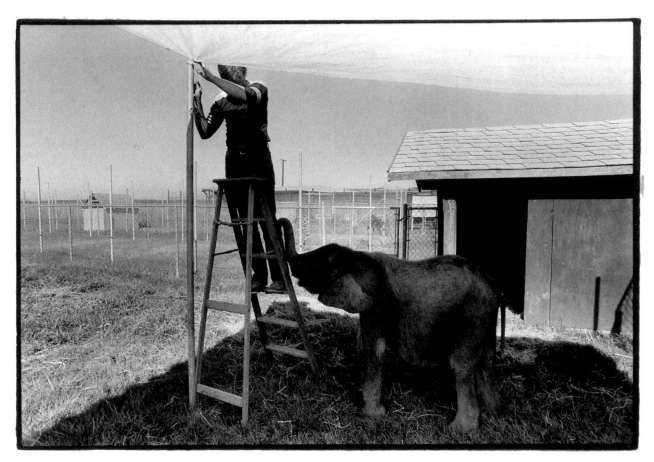

Lending a trunk.

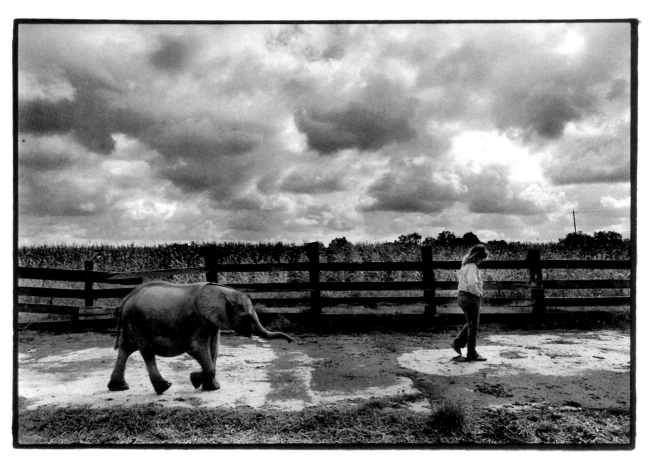

Stormy afternoon.

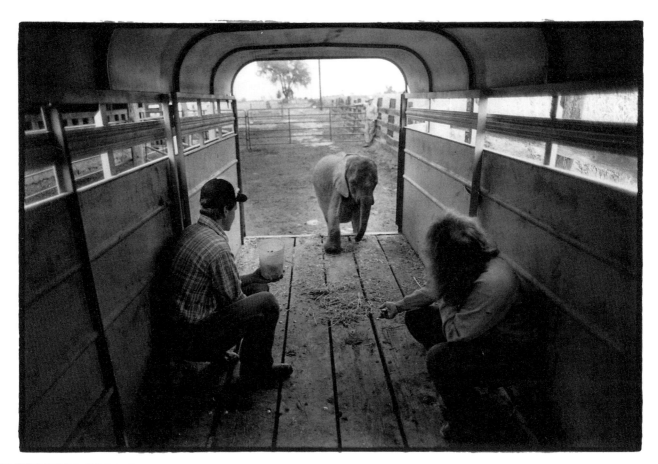

Wary of change.

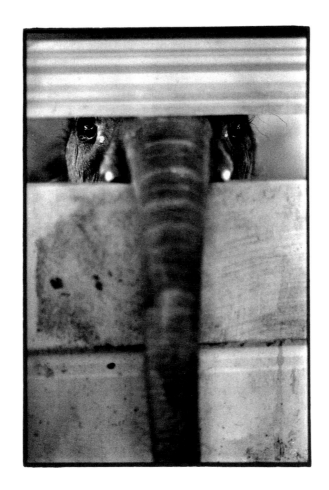

"71" is still curious.

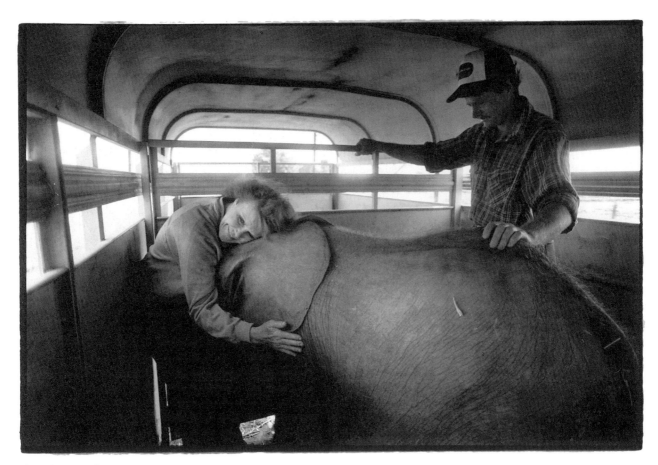

She takes comfort…

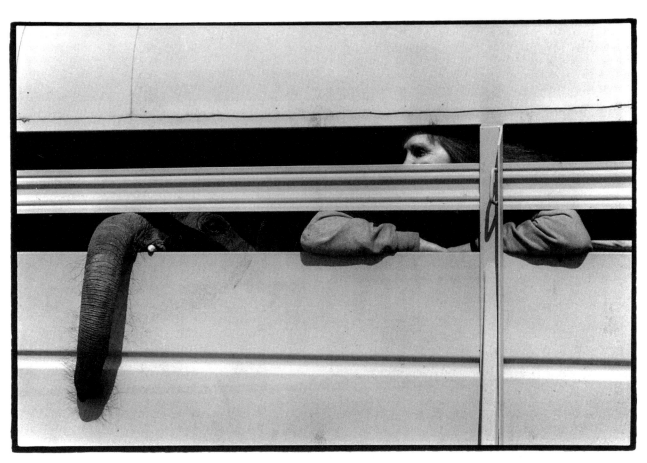

in traveling companions.

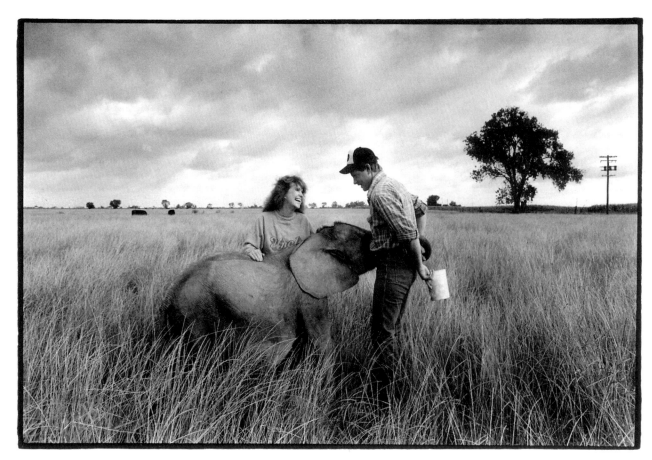

A bucketful of apples.

2.

Just one of the family

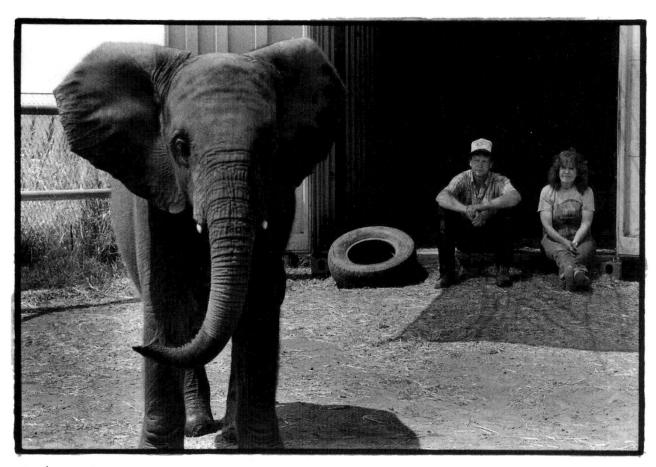

Family portrait.

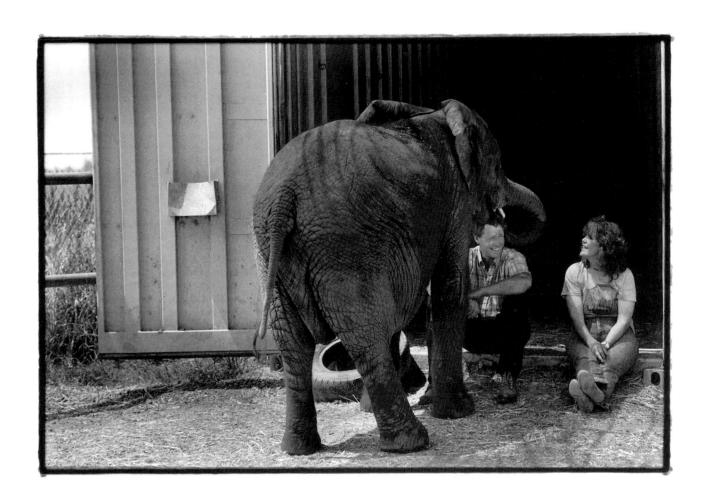

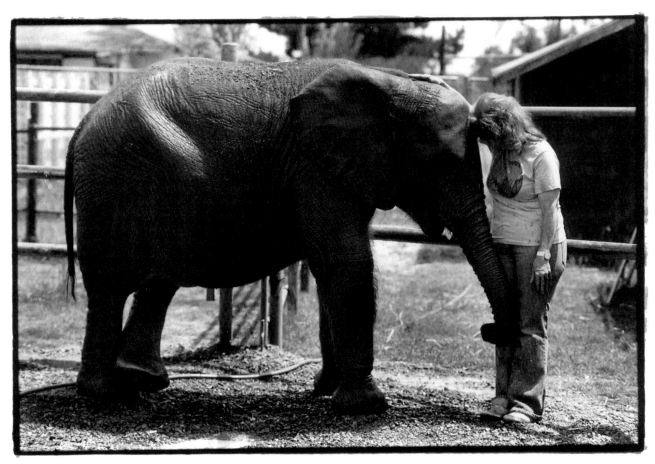

Meeting of the minds.

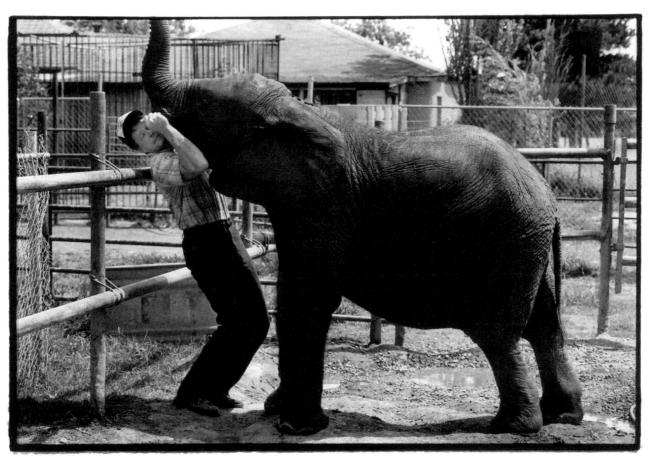

"71"'s affection can be overwhelming.

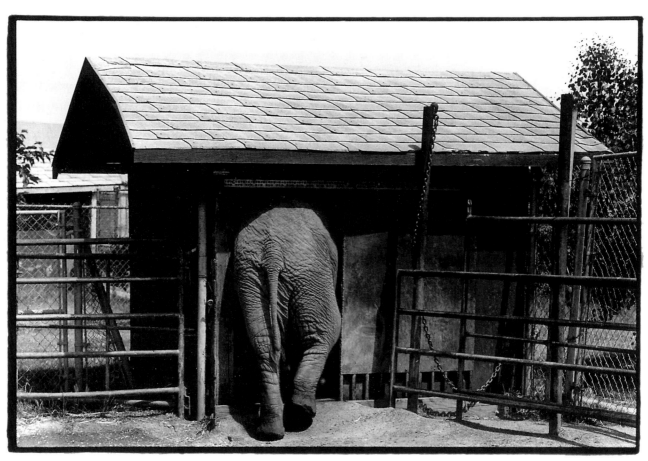

A tight fit…

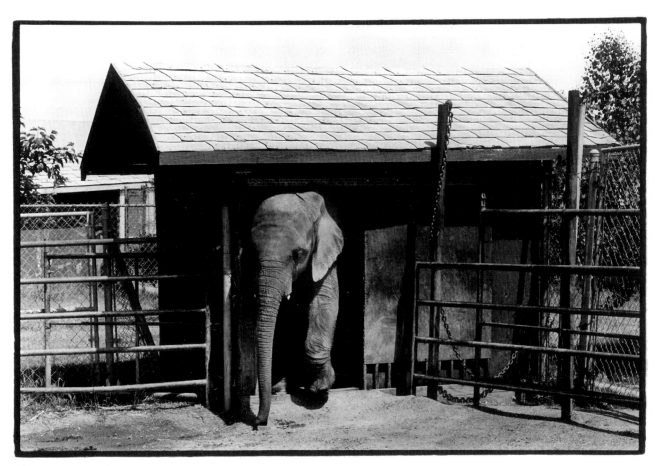

for a growing girl.

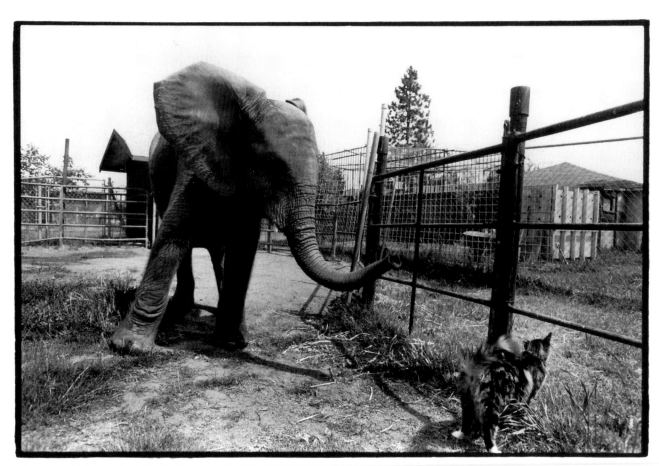

Fearless Clyde.

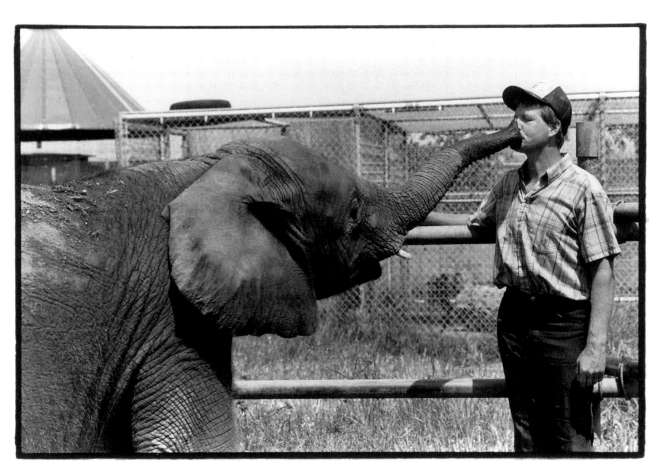

Bigger elephant. More slime.

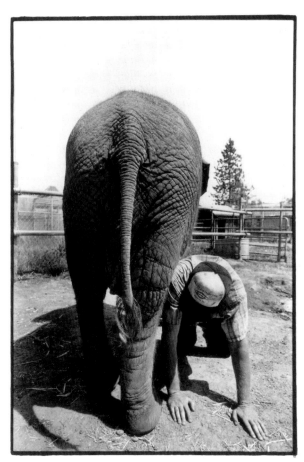

Ed outmatched.

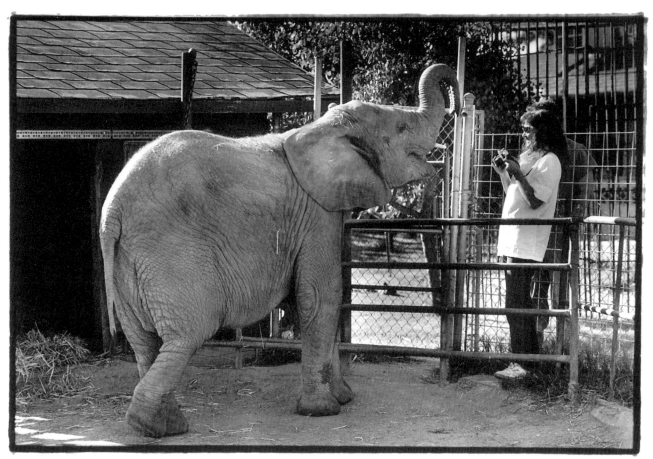

Hamming for the camera.

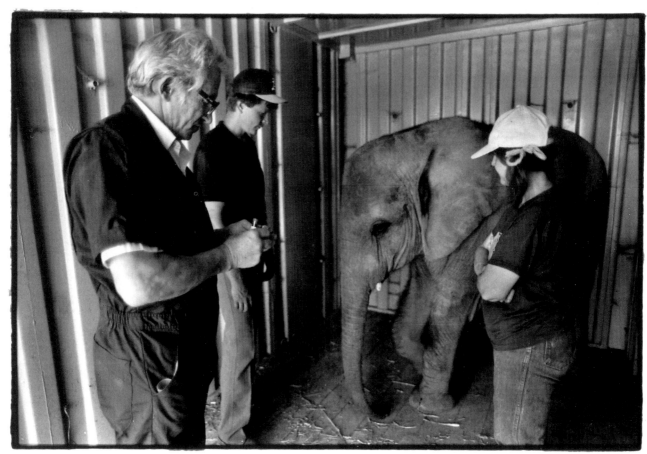

House call.

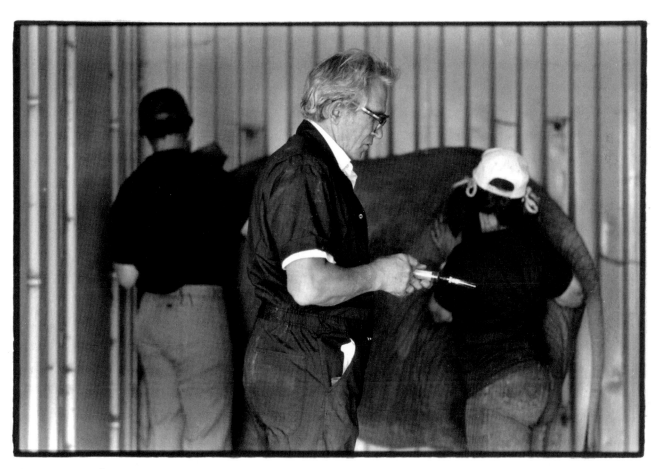

Dr. Murray Fowler prepares an injection.

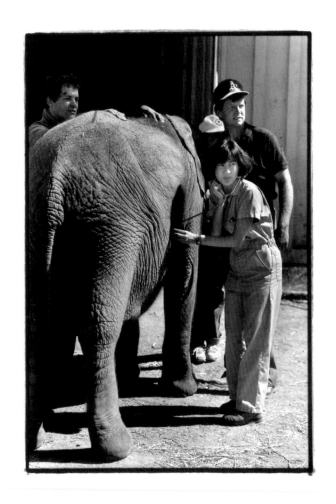

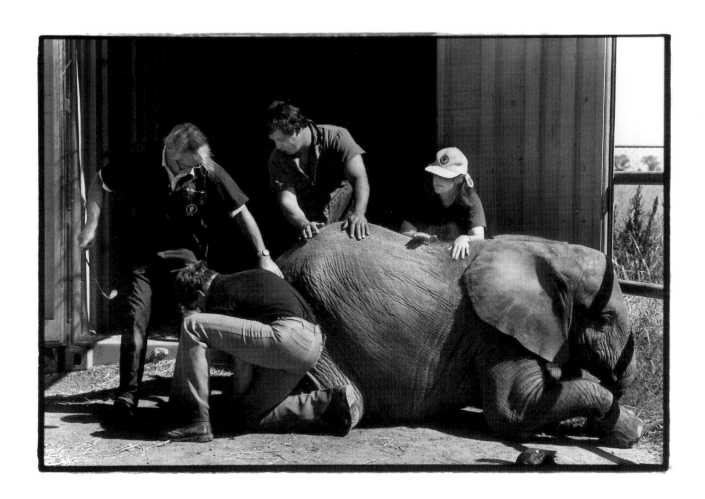

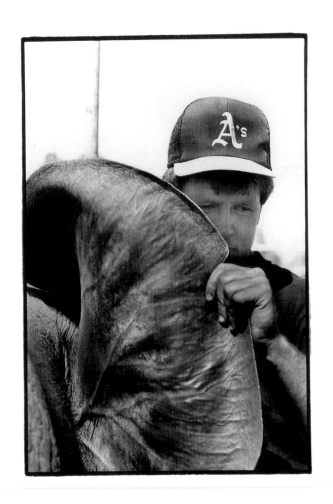

50

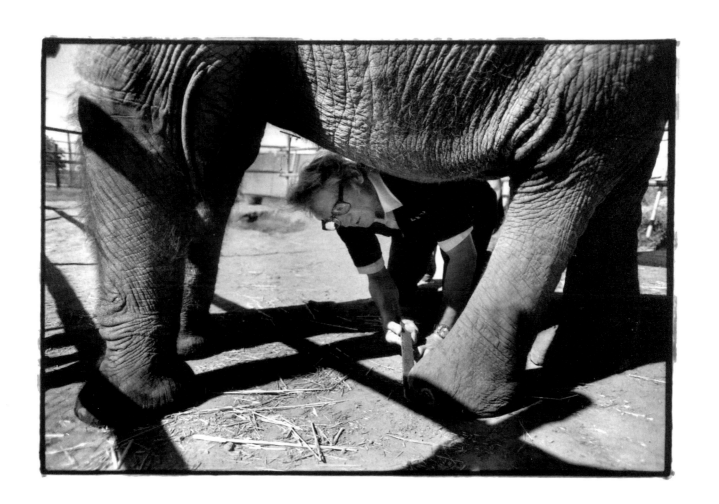

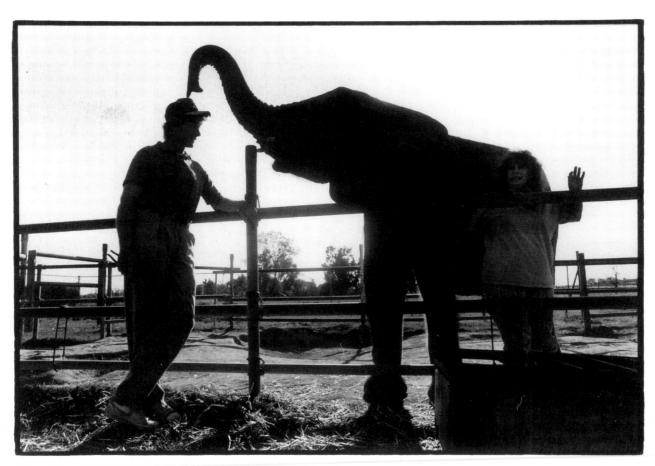

Ed and Pat spend time with "71" at the end of the day.

3.

Mara

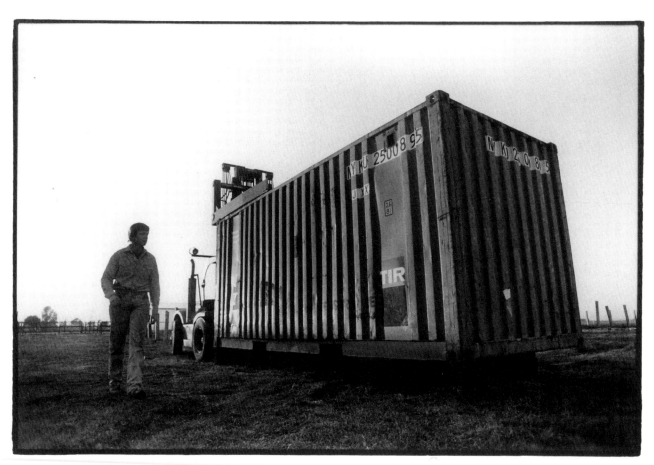

Mara arrives in Galt.

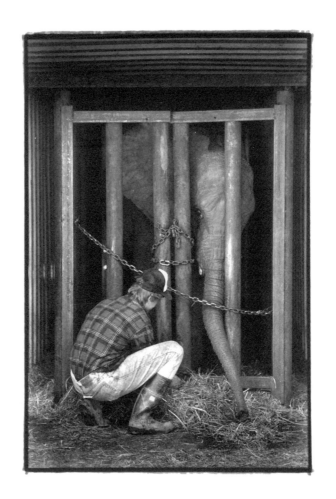

Ed unlatches the gate.

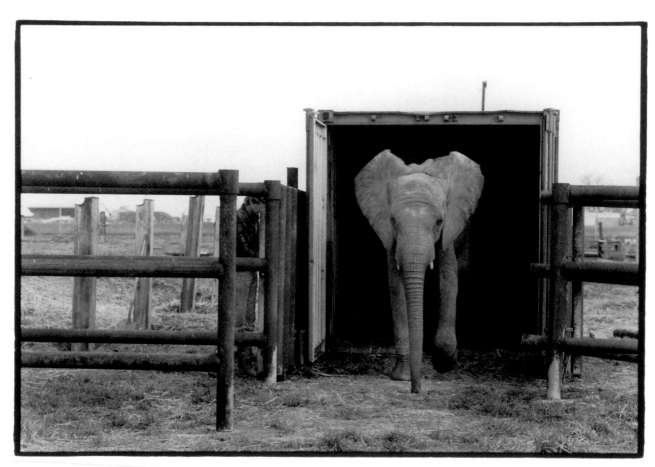

In a rage…

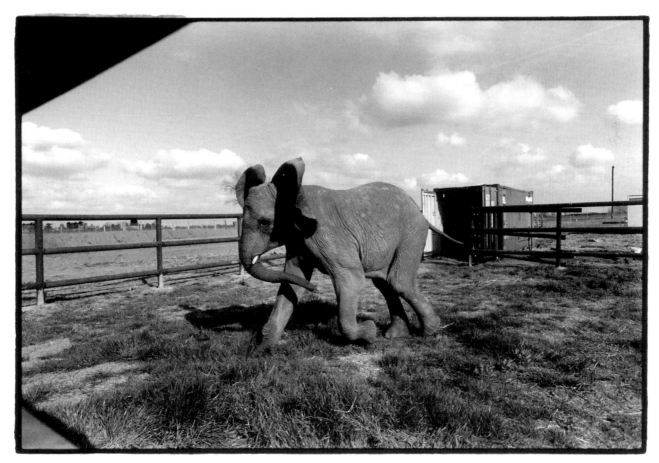

Mara charges…

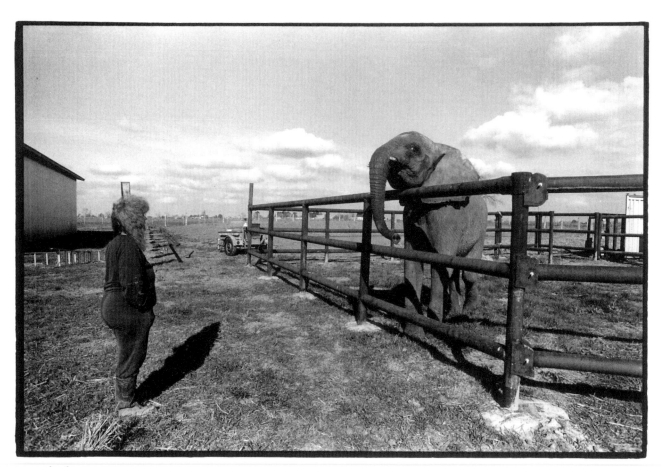

everybody…

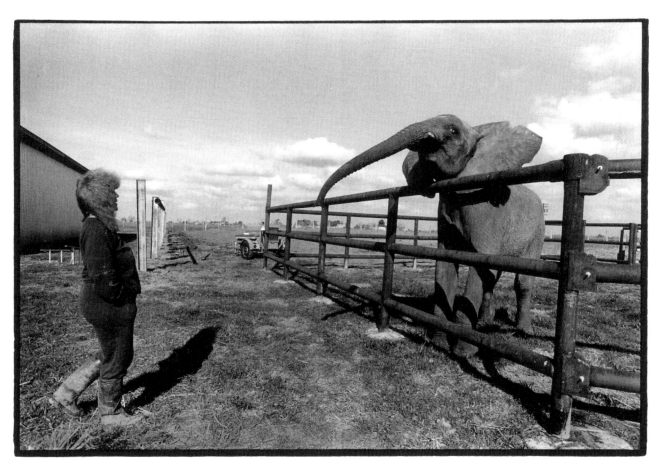

even Pat.

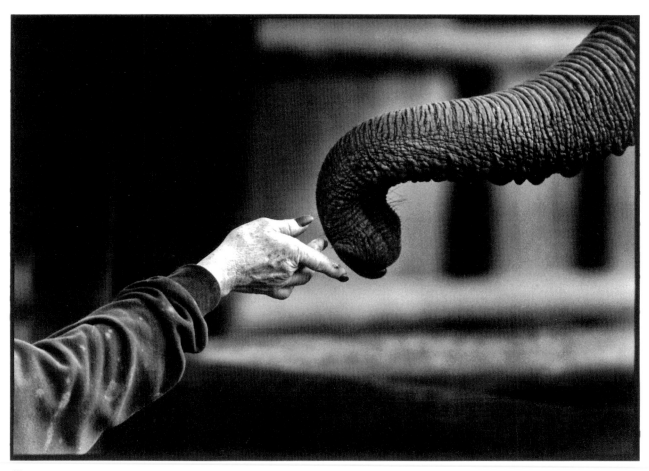

First contact.

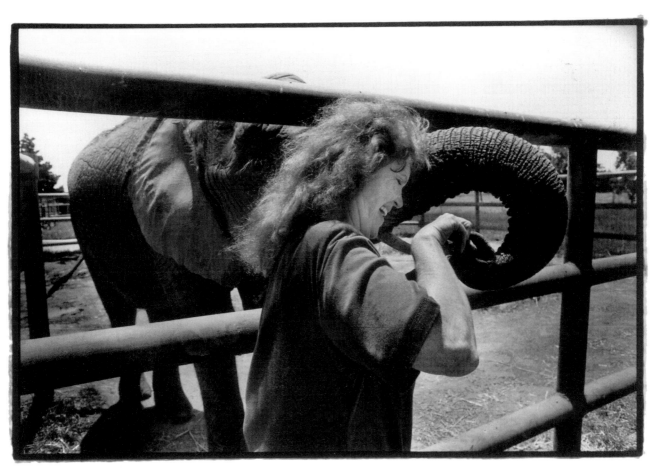

Reaping the rewards of bribery.

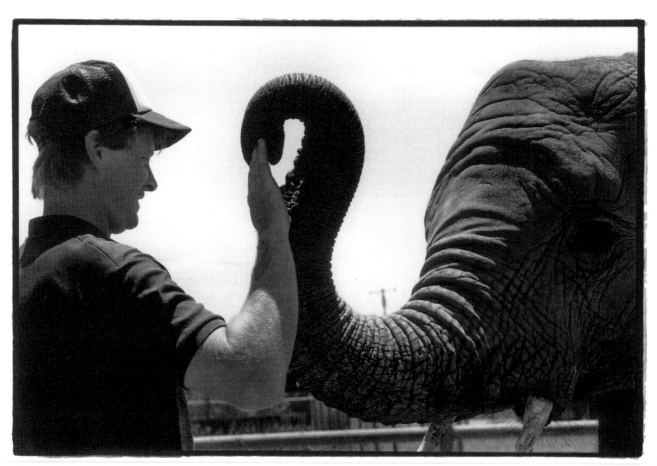

Greetings.

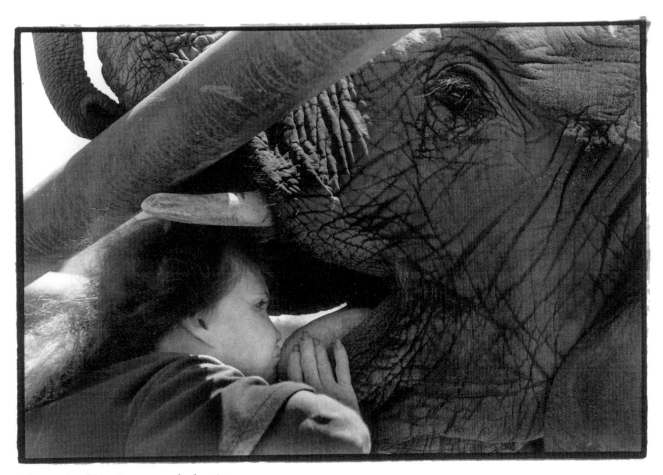

The magic of blowing on an elephant's tongue.

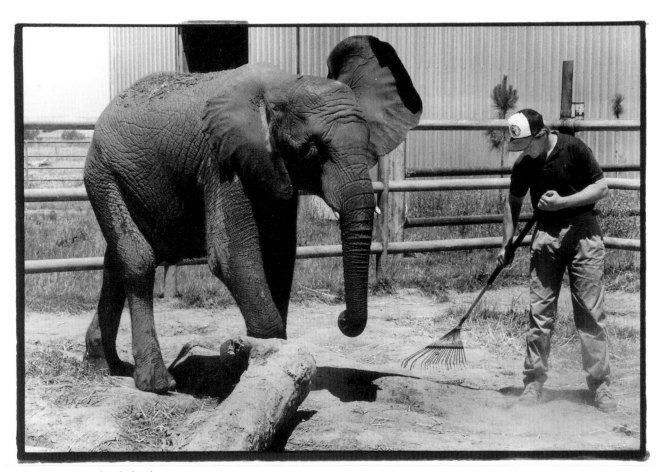

Mara oversees the daily chores.

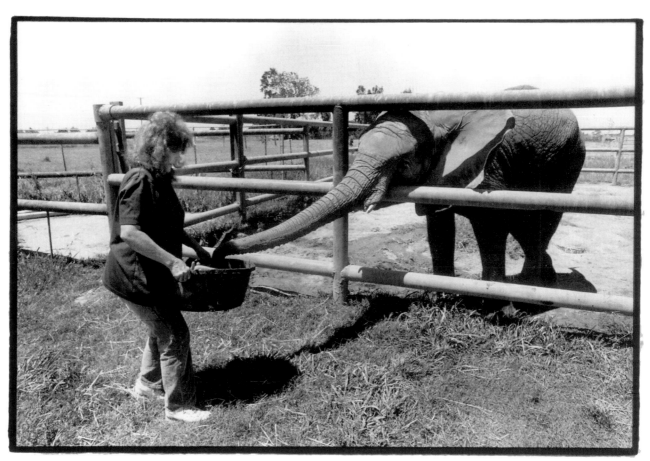

Stealing apples.

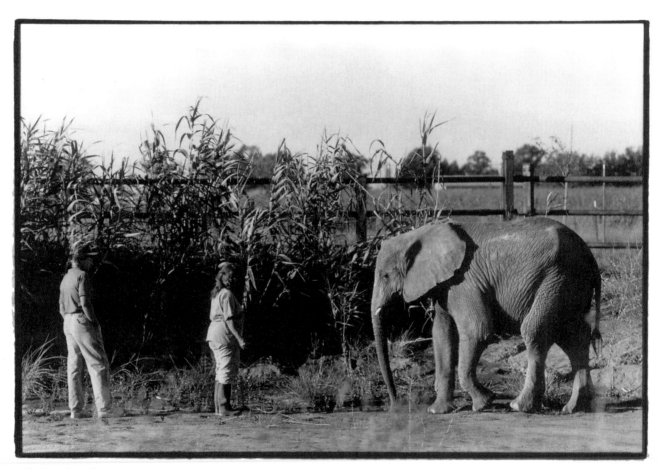

The bamboo forest.

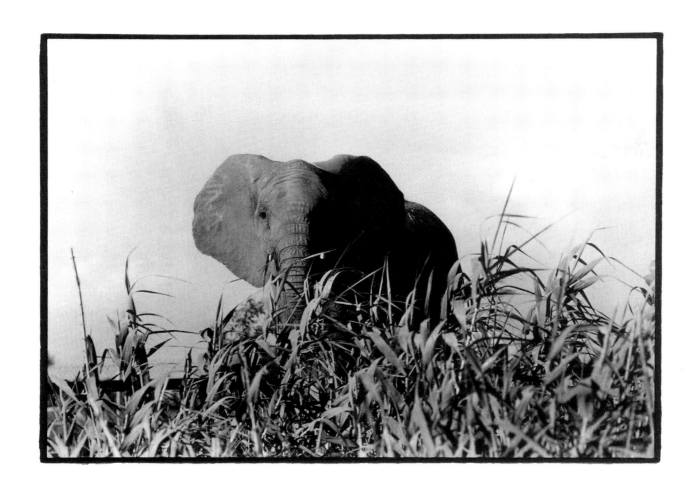

4.

In the presence of elephants

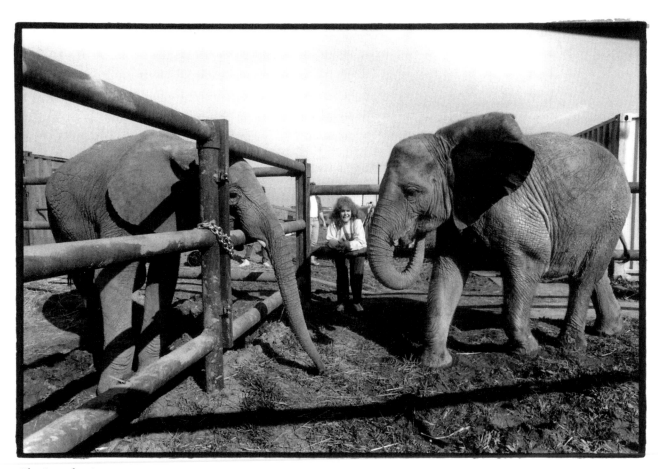

The introduction.

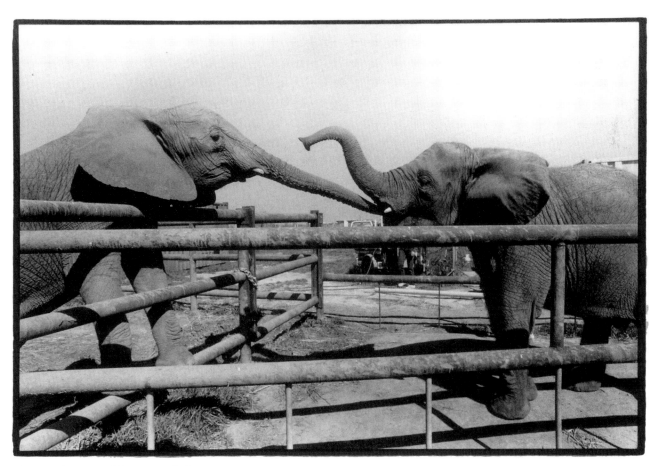

A critical gesture: Mara extends her greeting.

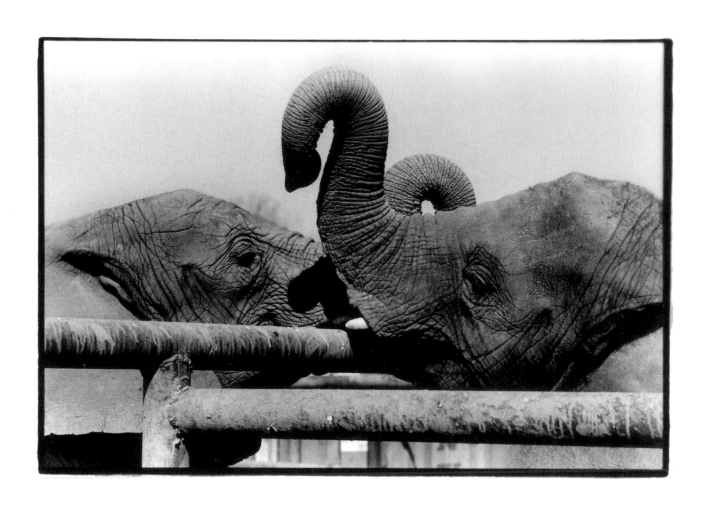

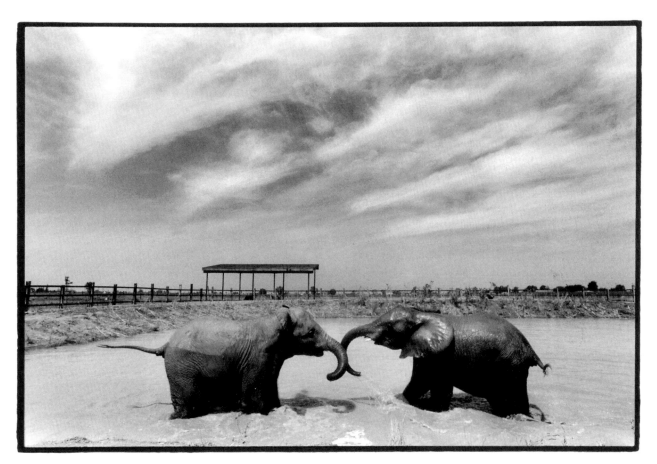

Two elephants, one herd.

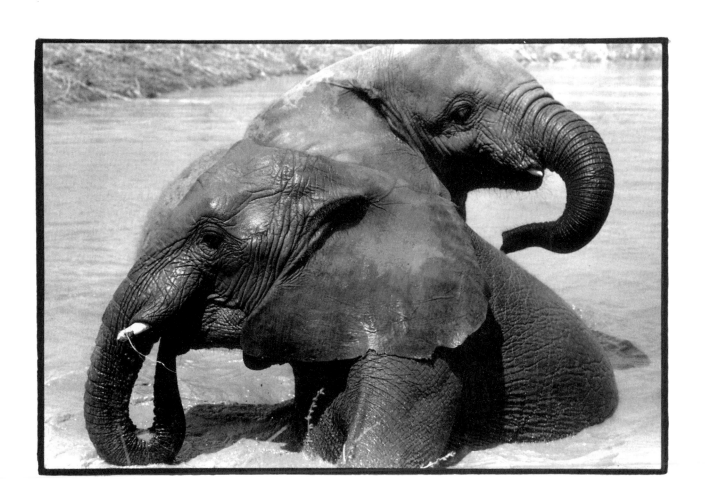

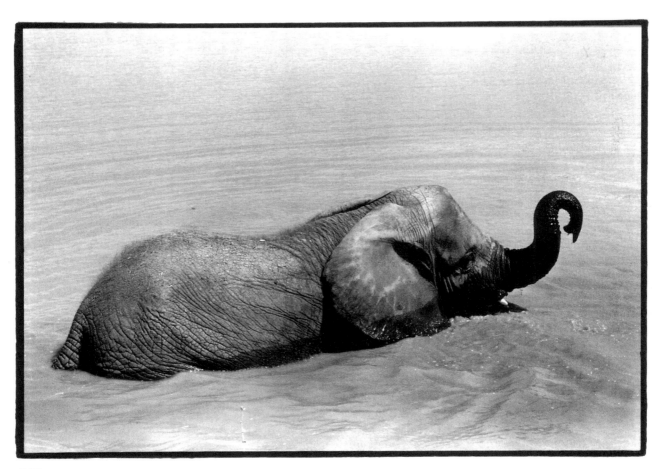

"71" swimming.

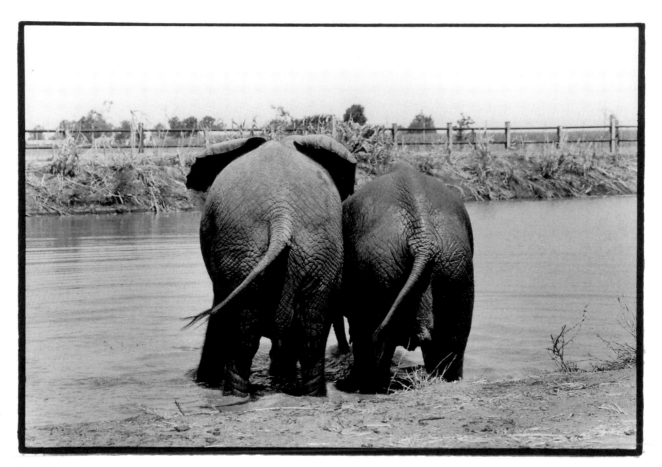

Mud dance.

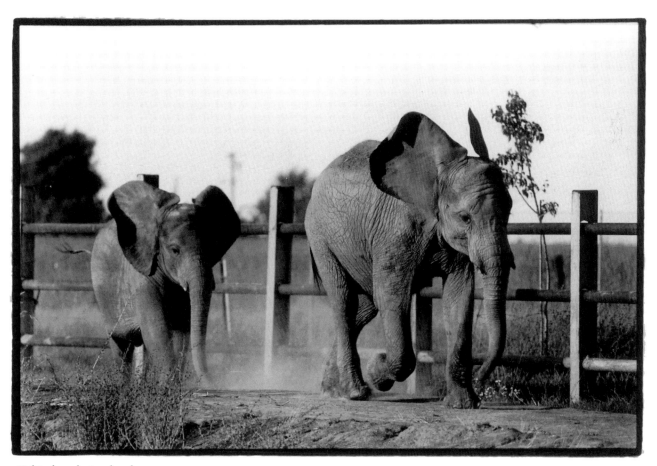

Galt's thundering herd.

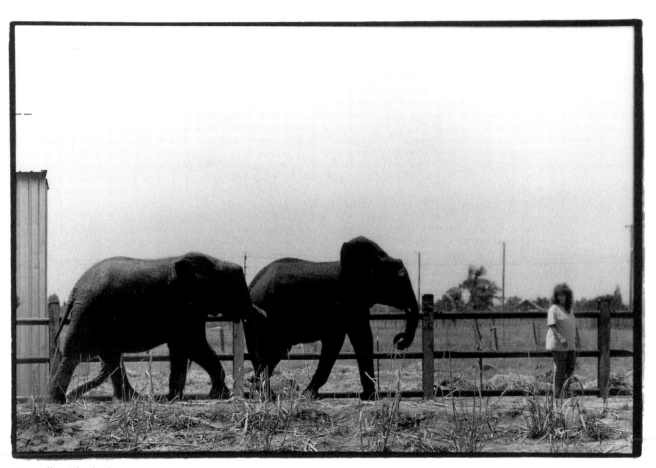

To walk with elephants.

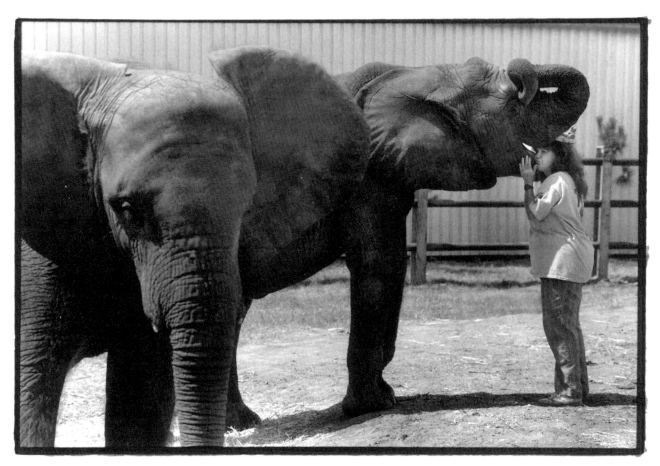

Time out…

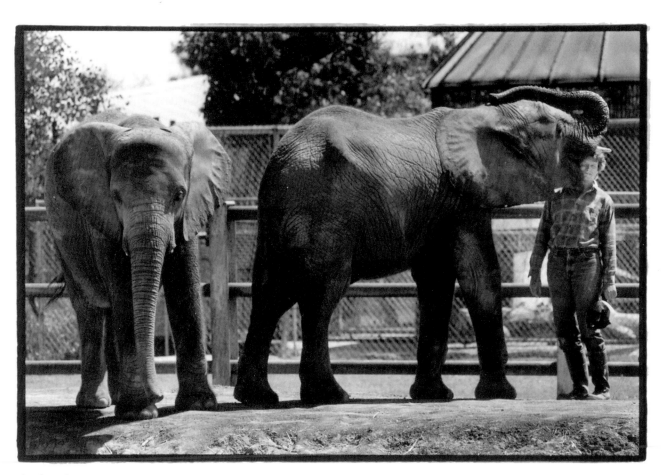

for friends.

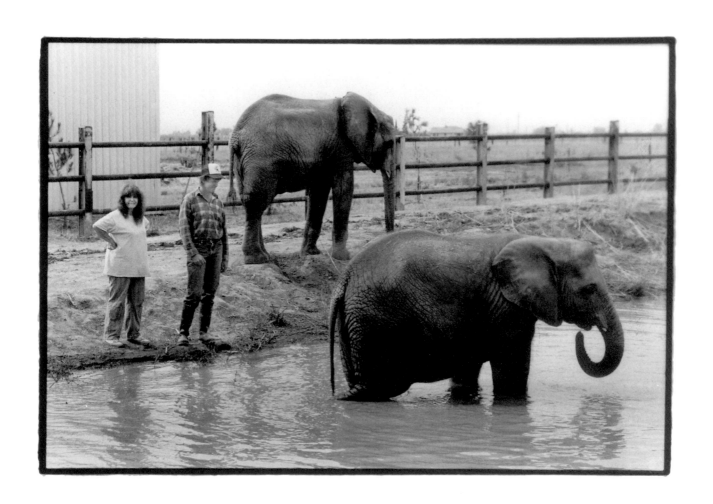

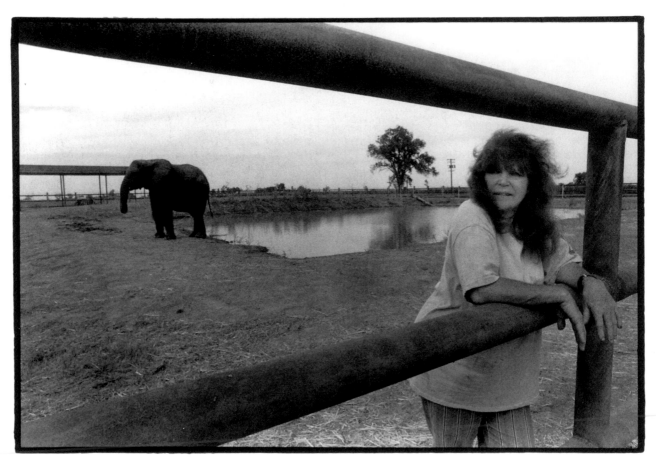

A dream realized.

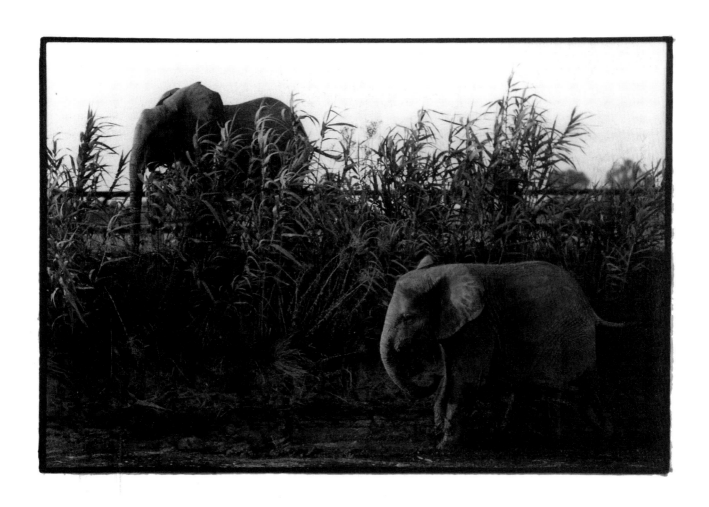

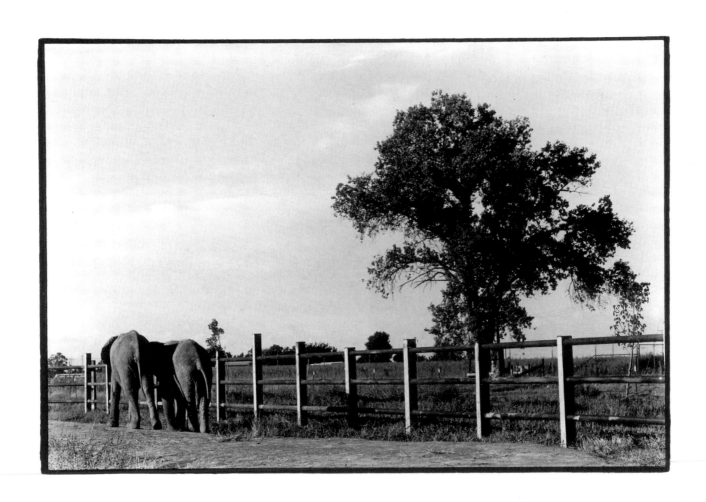